CITY DOGS

EDITED BY J. C. SUARÈS

CollinsPublishersSanFrancisco

A Division of HarperCollins*Publishers*

First published 1994 by Collins Publishers San Francisco
Copyright © 1994 J. C. Suarès
Captions copyright © 1994 Jane R. Martin
Additional copyright information page 80
All rights reserved, including the right of reproduction
in whole or in part in any form.

Library of Congress Cataloging-in-Publication Data

City dogs / edited by J. C. Suarès.
p. cm.
ISBN 0-00-255252-3
1. Photography of dogs. 2. Dogs—Pictorial works.
I. Suarès, Jean-Claude.
TR729.D6C57 1993
779'.32—dc20 93-31565
CIP
Printed in Italy
2 4 6 8 10 9 7 5 3 1

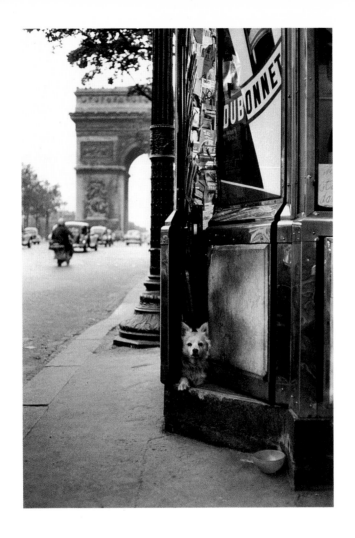

SABINE WEISS
Newspaper Stand
Champs-Elysées, Paris, 1955
"This little dog, the same kind all the taxi drivers had at the time,
belonged to the newsstand owner. His only diversion from a
constant view of the man's legs was his view of the street."

A pack of wild dogs running down the Corniche, the fifteen-mile promenade along the Mediterranean, was not an uncommon sight in the Alexandria (Egypt, that is) of the early 1950s.

The dogs looked like the painted wooden likenesses found in tombs of the later dynasties: lithe greyhound bodies, large jackal ears, long snouts dripping with foam.

Hungry and sick, they moved like a swarm of crazed bees. They overturned trash cans and stole from food carts. And Hanem, my Bedouin nanny, warned that they were known to attack children.

The wild dogs came from the desert. They had followed caravans and were now trapped. Perhaps they would find their way back to the desert where they could certainly survive on small mammals, but here they were doomed.

It wasn't until a quarter of a century later that I saw a pack of wild city dogs again. It happened on a stifling summer day on the way to the Bronx Zoo, when a wrong turn took a friend and me to a "bombed out" section of the city.

These dogs ran too. They ran across empty lots and along the abandoned buildings of Longfellow Avenue like a band of renegade mercenaries. They followed their leader, a large, wire-haired beast with red eyes and a worn red leather collar.

Most of the dozen or so beasts who followed him still wore collars of some kind, meaning that they had either been abandoned or had escaped from domesticity. In fact, a few of the dogs betrayed fancy pedigreed origins, Saluki or Bearded Collie perhaps. The rest were part or all German Shepherd or Doberman.

We ran into a van from the ASPCA and a couple of very tired but nevertheless dedicated workers, determined to catch up with the pack. They knew the big wire-haired leader by name and his whole story and although he had eluded their capture for weeks, they bore nothing but respect and a little pity for him.

His name was Chaney and he had once belonged to a young postal worker in Manhattan. It seemed that the young man had exacted a promise of marriage from a frail beauty whose only condition was that he get rid of the dog. The dog ended up in a parking lot somewhere near Gracie Mansion where he was tied up all day and never lavished with any attention.

As the story went, Chaney chewed through his leash and took off like a bat out of hell one night. He found himself in the wilderness

of the Bronx, soon met up with other dogs and became their leader. A kind of Robin Hood, determined to keep his and his followers' freedom intact.

Later the postal worker had a change of heart, and broke off his engagement. When he found out that the dog had escaped, he went nearly crazy with remorse and alerted all the city agencies he could find listed in the Yellow Pages.

I don't know if Chaney and his former master were ever reunited. Something tells me they were. It would be too sad to think otherwise.

J. C. Suarès

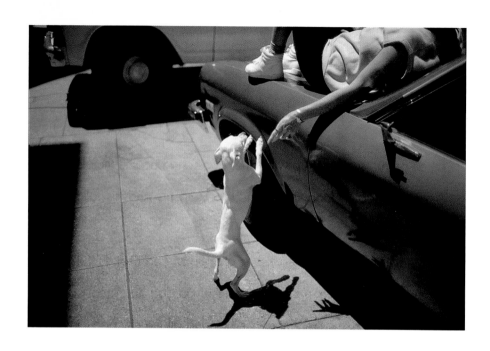

ANDREW J. HATHAWAY
White Dog Outside my Front Door
San Francisco, 1992
"My neighbor was sunning herself on her car when
I came outside. I think her dog was scared of me.
He reached up to her for reassurance, she reached down
to pet him, and there it was—
the hand of God from the Sistine Chapel."

Opposite:
ROBIN SCHWARTZ
Mural
New York, 1982

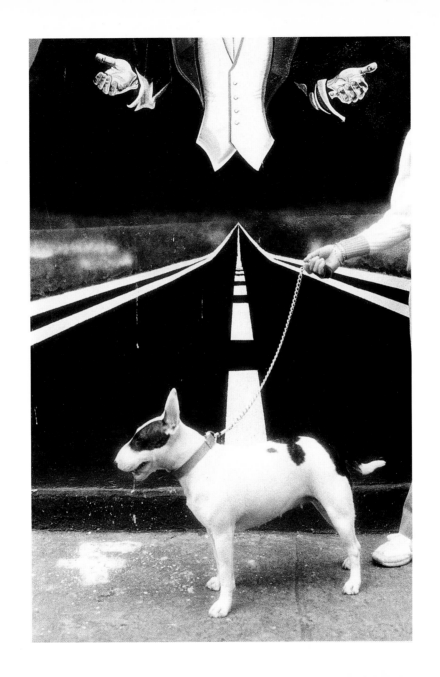

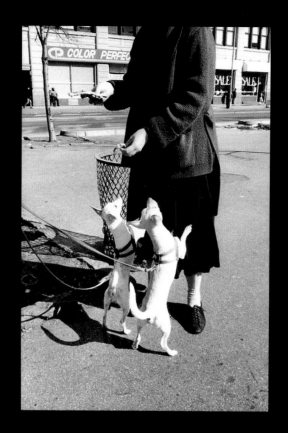

LIZZIE HIMMEL
Union Square Park
New York, 1991
"This woman took her two Jack Russell Terriers for an afternoon
constitutional in the park every day. They loved pizza and
kept begging her for some until she finally relented."

Opposite:
DAN WEINER
East End Avenue
New York, 1950

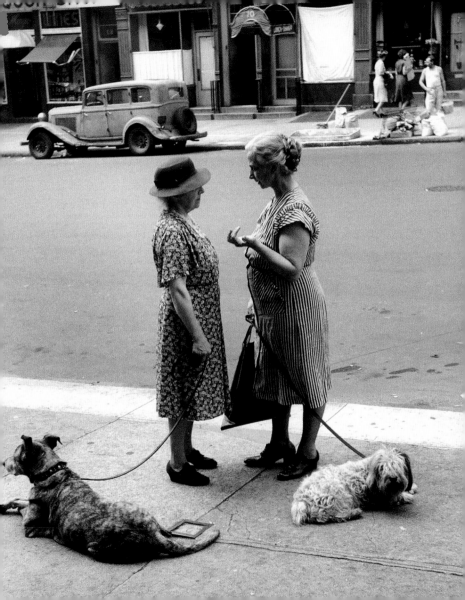

PHOTOGRAPHER UNKNOWN
Sleeping It Off
Cincinnati, Ohio, November 21, 1947
With trucks at a standstill on the third day of the 1947
truckers' strike, a dog named Sparkplug finds some rest
in the rear wheel of a tractor trailer.

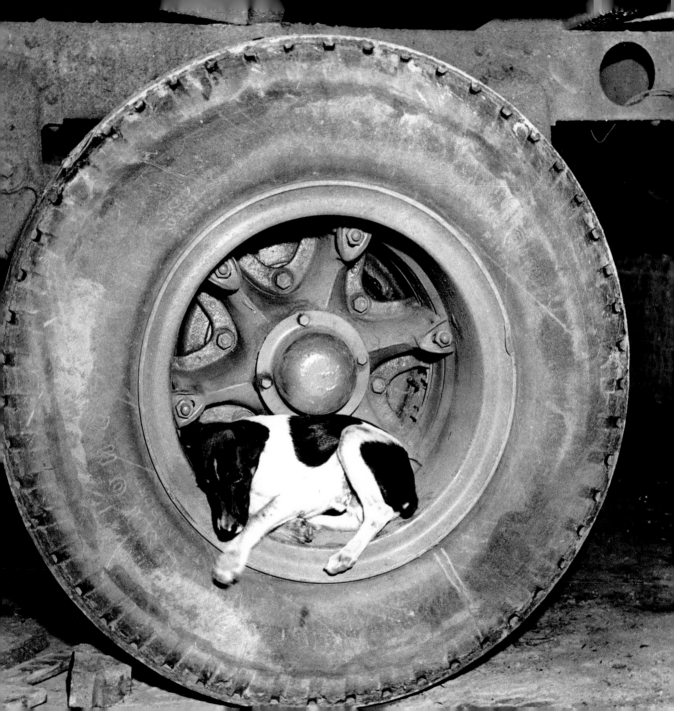

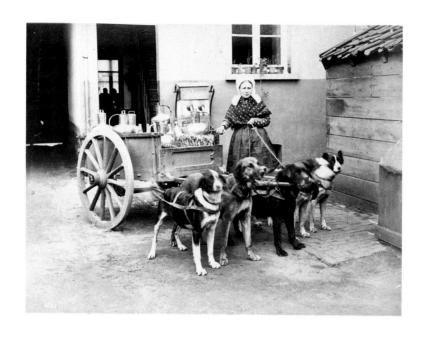

PHOTOGRAPHER UNKNOWN
The Milk Wagon
The Netherlands, c. 1900

Opposite:
KATHERINE O'CONNOR
John Mansill's Dog
County Kerry, Ireland, 1992
"When I showed some people this photograph, they said,
'Oh this poor, poor dog—he's all locked up.' Other people said,
'No, he's got a good life. He's got a trailer all to himself.'
I've since found out that his owner was a breeder, and that he built
the trailer so his dogs could ride in style went they went to town."

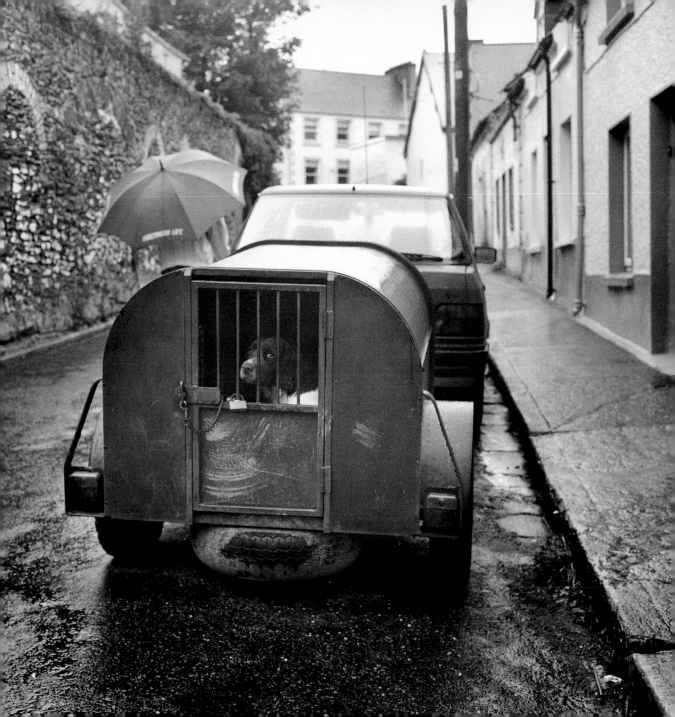

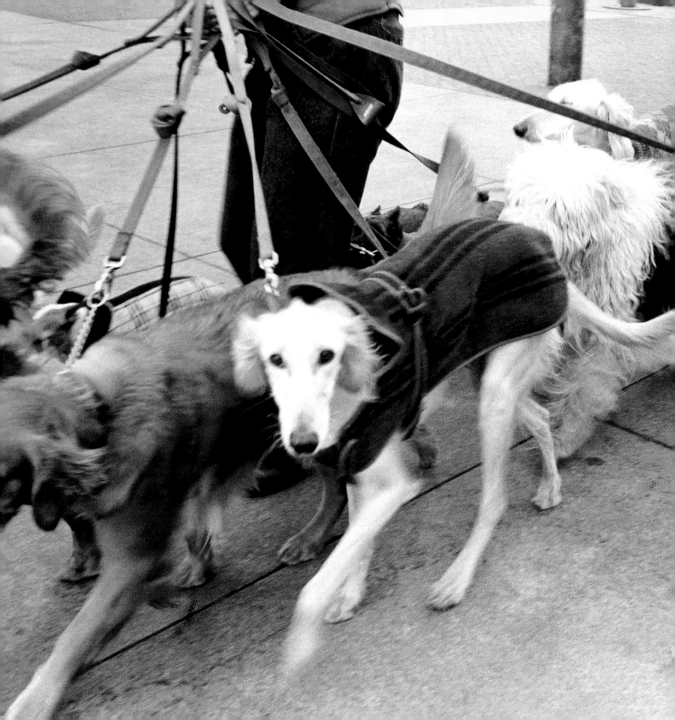

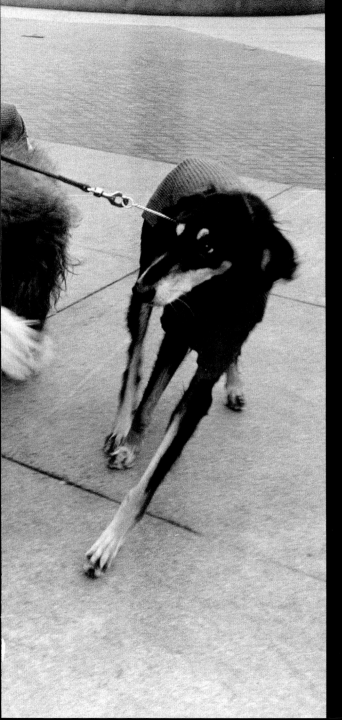

AMY ARBUS
Dog Walker
New York, 1985
"Kasbeck; the white Saluki, in a striped Tyrolean jacket; Faubion,
the black and silver champion Saluki, in a ribbed sweater;
Natalie, a Jack Russell Terrier in a plaid Paris original, and friends
walking by the Metropolitan Museum in the morning."

17

Alice Wingwall
Discussion in the Galeries Vivienne
Paris, 1990 (detail)
"The dog had been sitting there for a while. A lot of people
looked at him as they passed, but this woman
started a conversation. She was telling him he was
beautiful and well-behaved and so on."

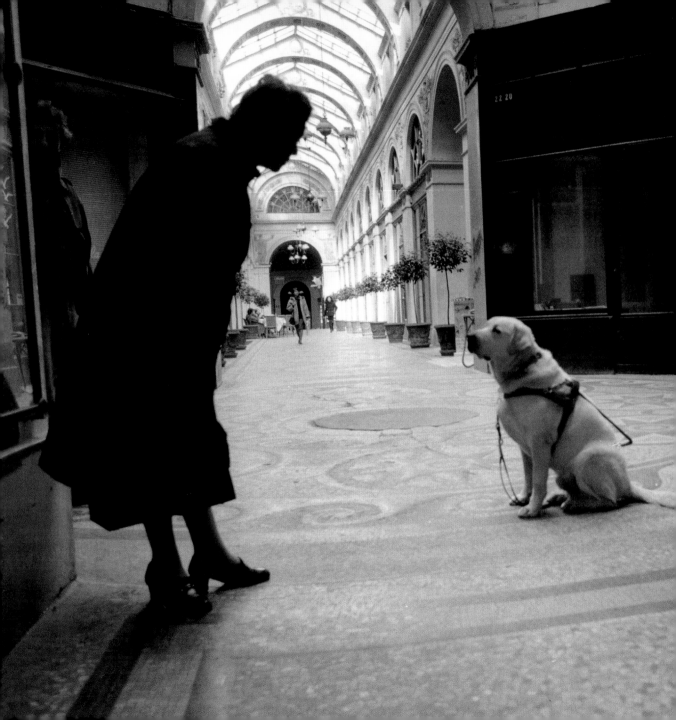

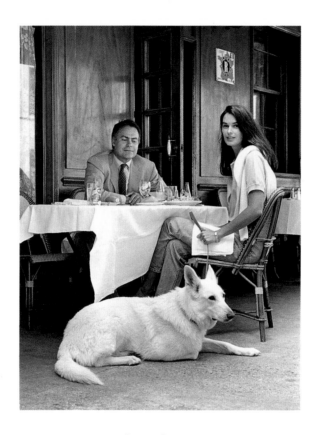

PRISCILLA RATTAZZI
Jean et Diane De Noyer and Sugar
New York, 1988

Opposite:
HAROLD FEINSTEIN
It's a Deal
Paris, 1988
"Most of the time the dog looked away but every once in a while
he'd look up, as if he were following the conversation."

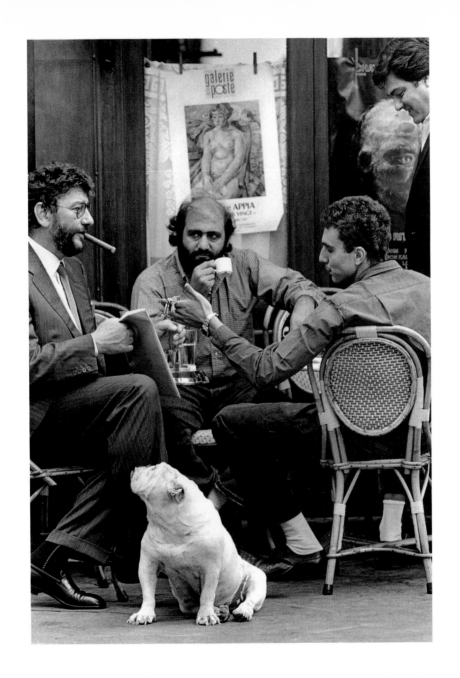

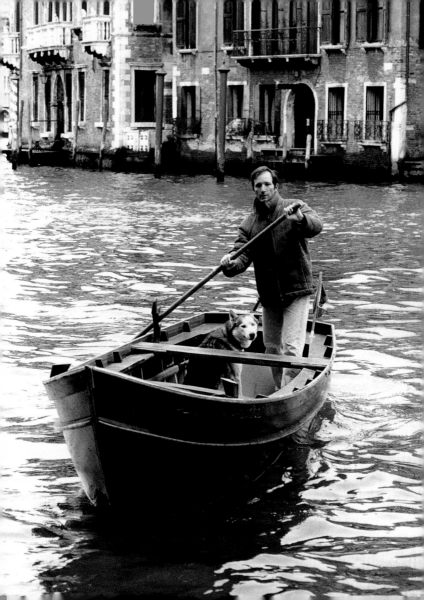

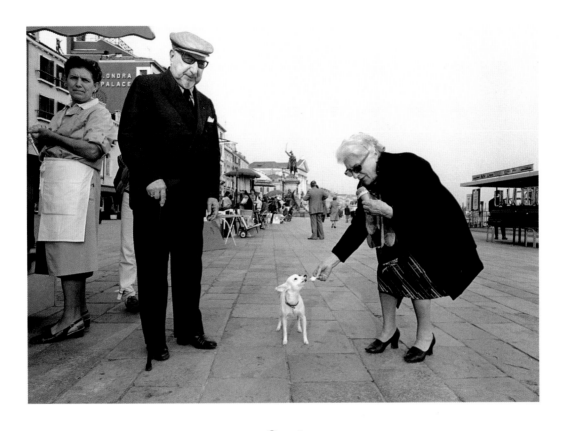

Opposite:
PRISCILLA RATTAZZI
Brandino Brandolini and Lev
Venice, 1988

JON FISHER
Venice
Italy, 1991
"I was walking near the Piazza San Marco
along the promenade of the Grand Canal
when I came across this gelato-eating Chihuahua."

J. WALDORF
Cautious Canine
Walthamstown, England, March 17, 1947
During one of England's worst floods, the water-shy Monty
sought refuge on top of a can. His owner rescued him
by persuading him to jump to a waiting boat.

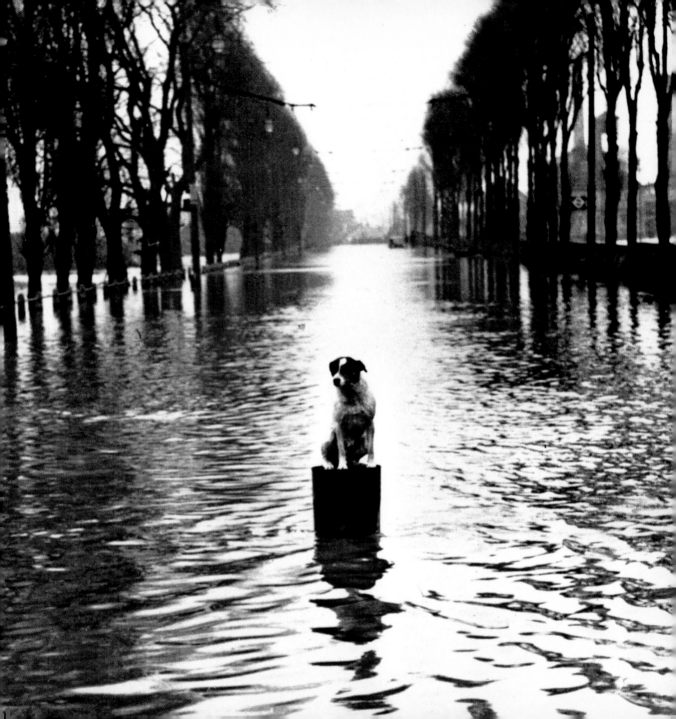

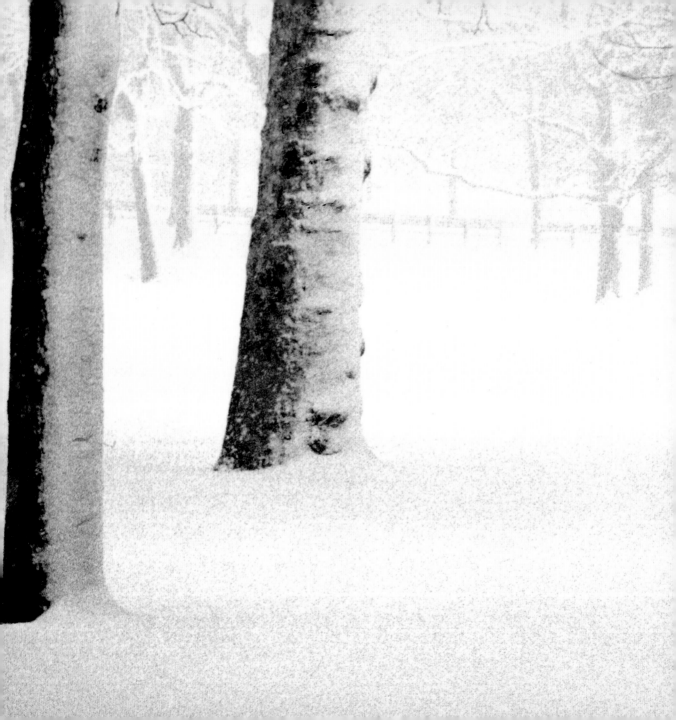

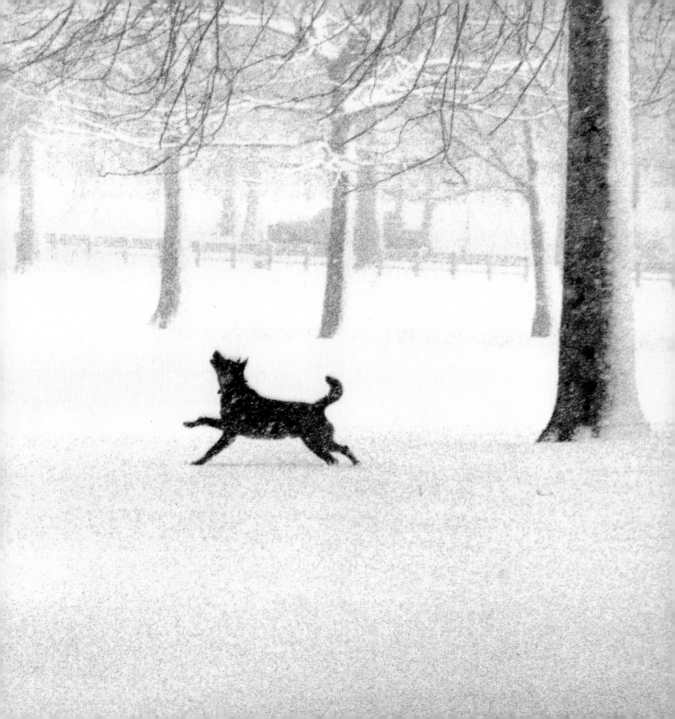

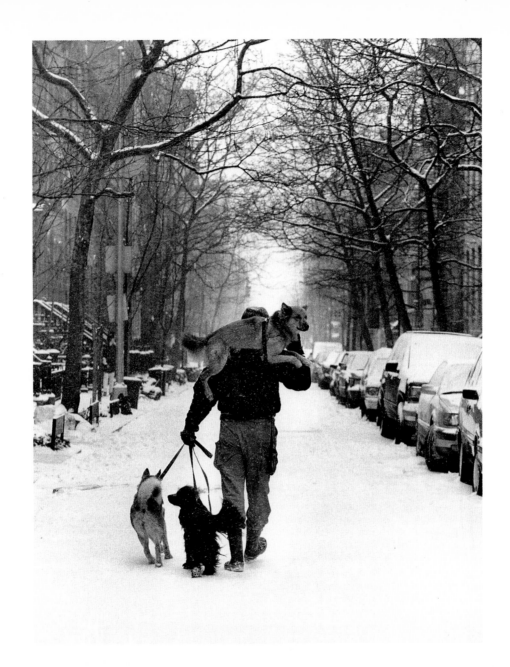

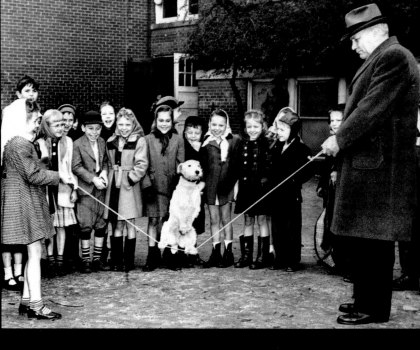

PHOTOGRAPHER UNKNOWN
The Governor Lends a Hand
Charlotte, North Carolina, March 28, 1948
North Carolina's Governor Cherry and Elmer the performing dog
give a traffic safety lecture to schoolchildren. Elmer, owned along
with six other trained dogs by Ernest E. Presley of the Charlotte
Police Force, played a lead role in the two-year safety campaign.

Opposite:
PHOTOGRAPHER UNKNOWN
Beastly Affairs
New York, 1908
From a series of Victorian animal postcards produced by
the Rotograph Company of New York.

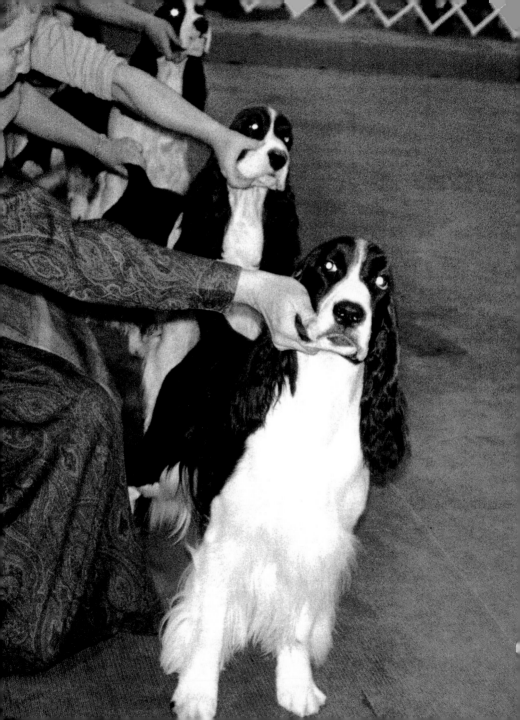

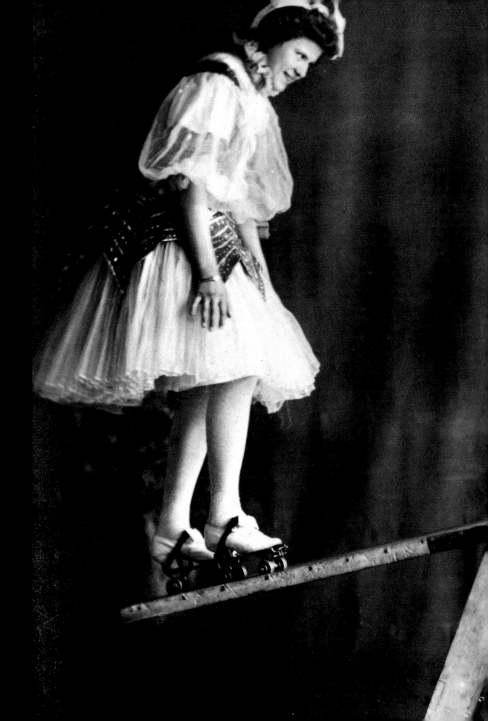

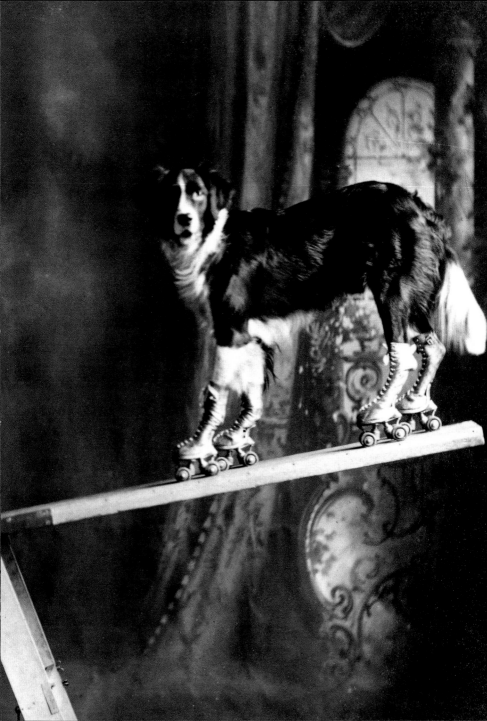

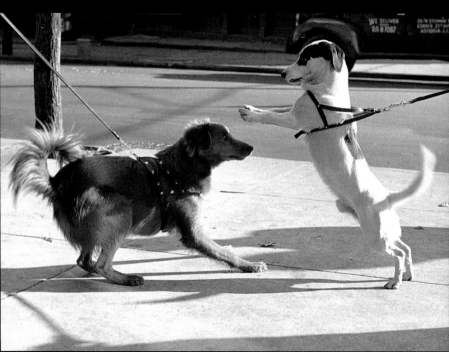

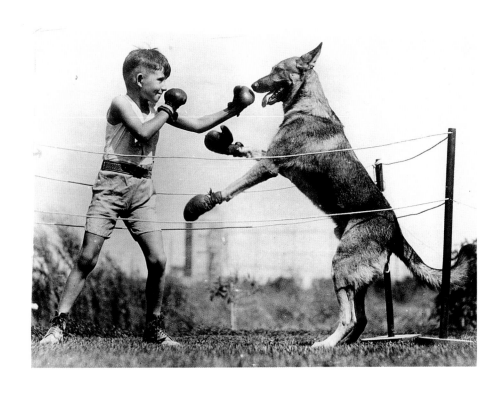

PHOTOGRAPHER UNKNOWN
Boy Boxes Dog
Los Angeles, September 10, 1926
Battling Von, a ten-month-old German Shepherd,
went four rounds with little Ralph Miller during a mock
West Coast Juvenile Police Dog Welterweight Championship.
The match was declared a draw.

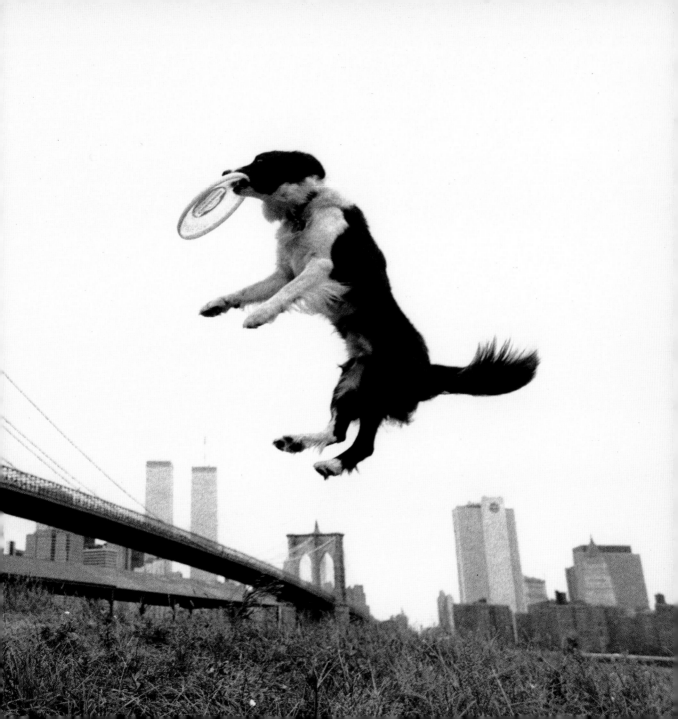

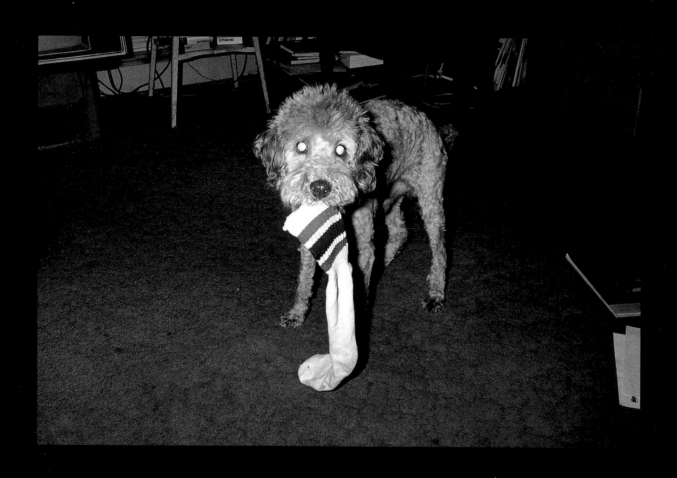

Karl Baden
U-Boat
Cambridge, Massachusetts, 1991

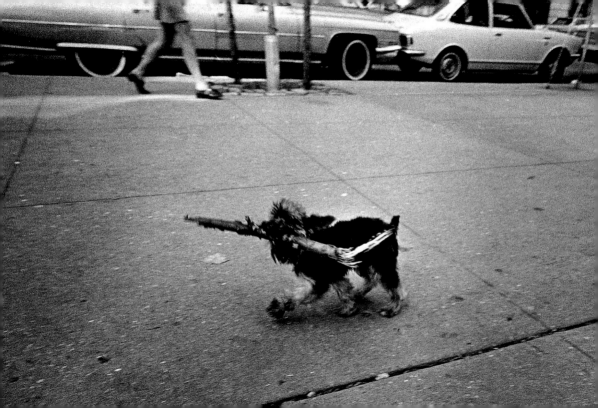

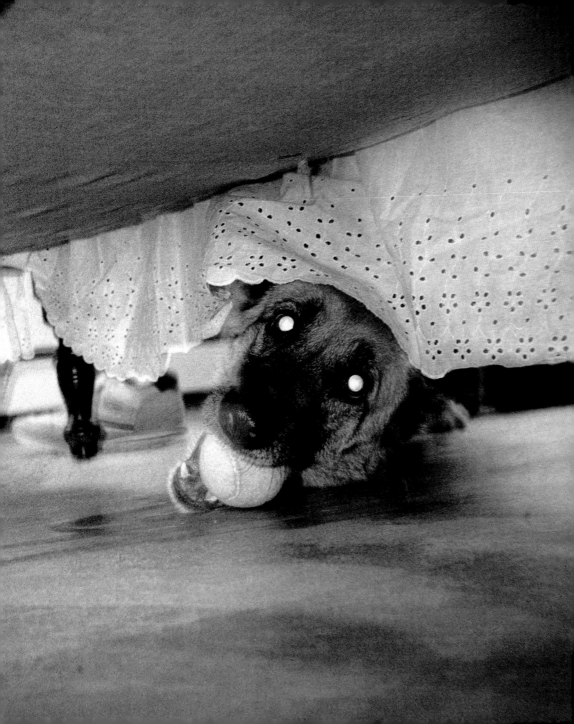

LINDA RASKIN
Untitled
Parking Lot, Grand Canyon, 1986

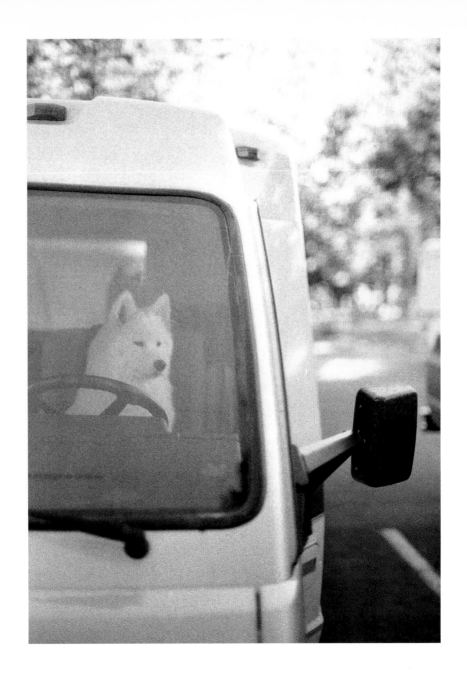

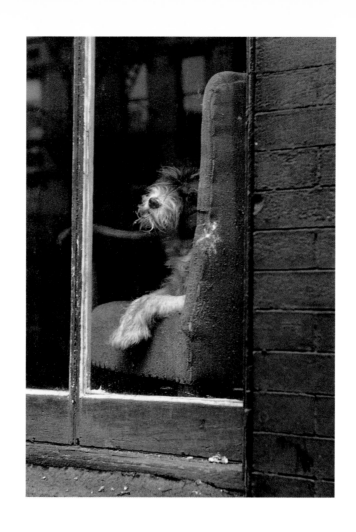

SID KAPLAN
New York City, 1955

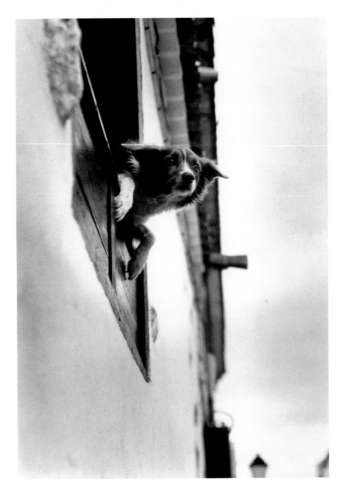

MARK MCQUEEN
Street Dog
Tenerife, Canary Islands, 1990
"Like most of the dogs I photograph, I saw this one
once and never again. But he was my first dog of the 1990s.
It was New Year's Day in Los Christianos, a port town of Tenerife,
and though the dog had a nice view of the ocean he was
more interested in the goings-on in the street."

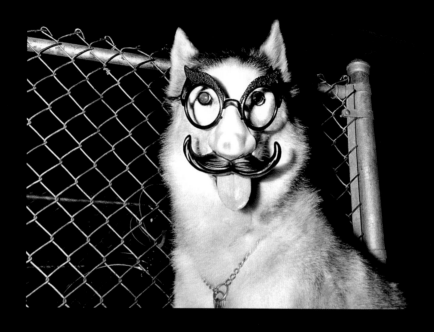

KARL BADEN
Badger
Cambridge, Massachusetts, 1981

Opposite:
JOYCE RAVID
Doberman
New York, 1985

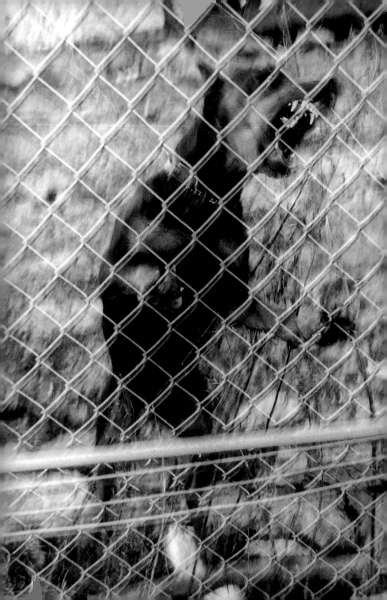

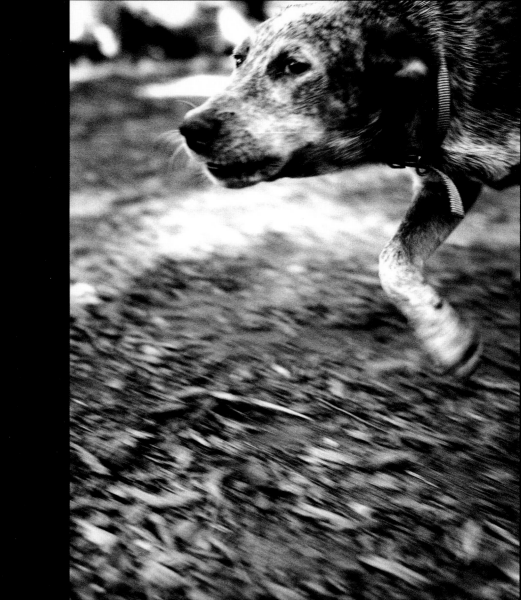

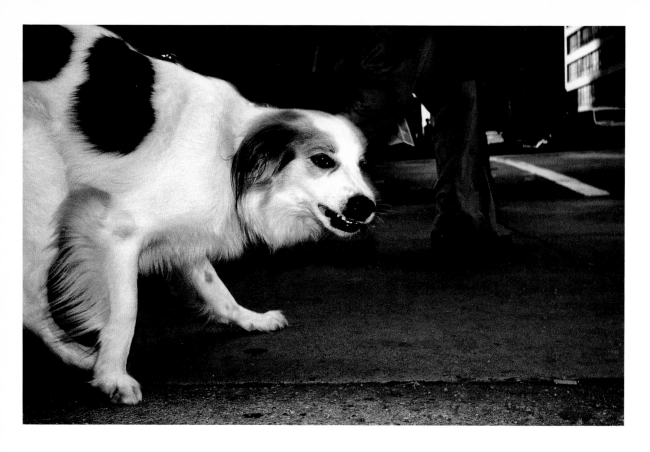

Preceding Pages:
Ann Giordano
Bark No. 8, Attitude, Stuyvesant Square Park,
and *Bark No. 21, Preservation, Tompkins Square Park,* 1991
Red, an Australian Blue Heeler, and company—
from the *Bark* series of twenty-two photographs.

Above:
Jean Pigozzi
Untitled
1979

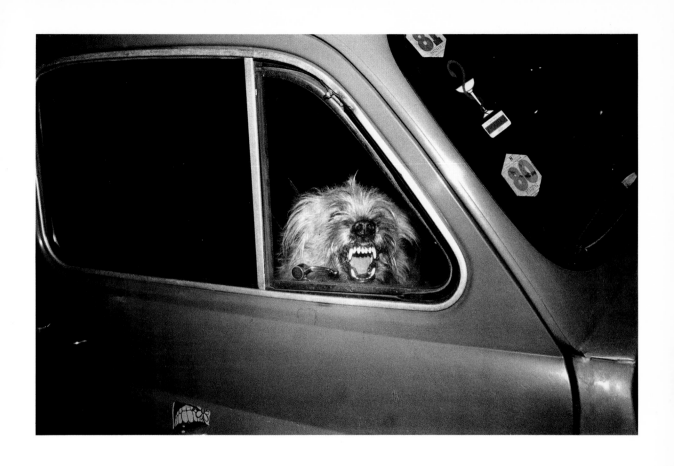

JEAN PIGOZZI
On the Champs-Elysees
Paris, 1981

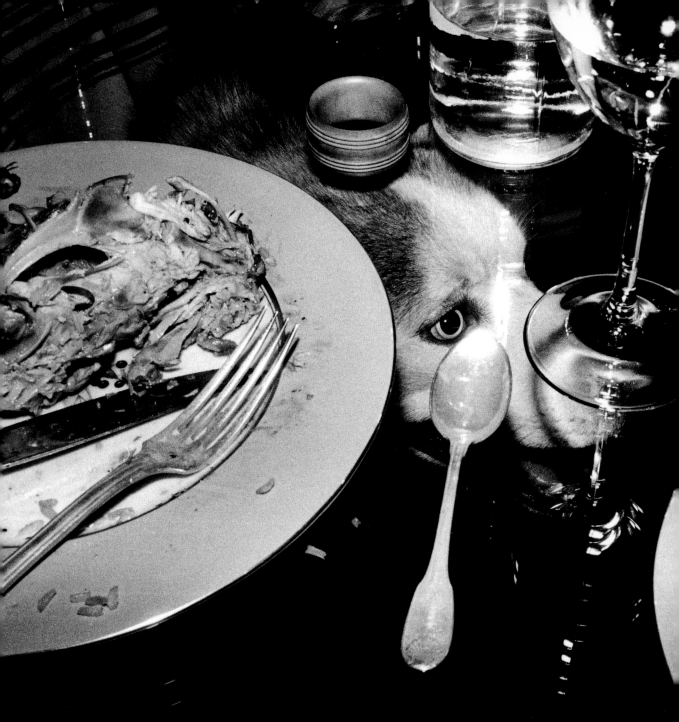

JEAN PIGOZZI
Sasha, the Wenners' Ex-Dog
New York, 1984

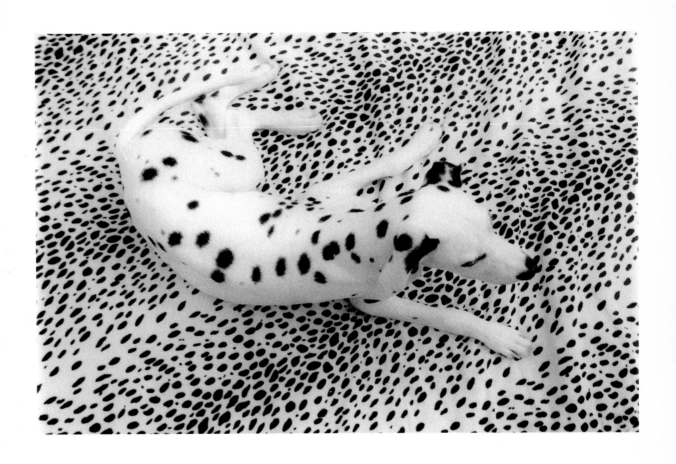

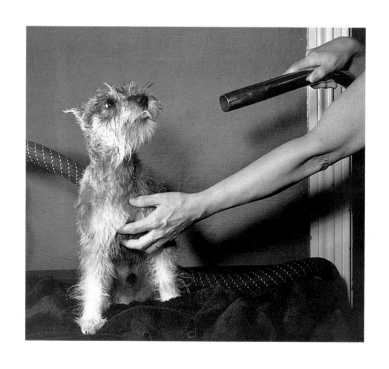

ILSE BING
Staccato Being Shampooed and Dried
New York, c. 1948

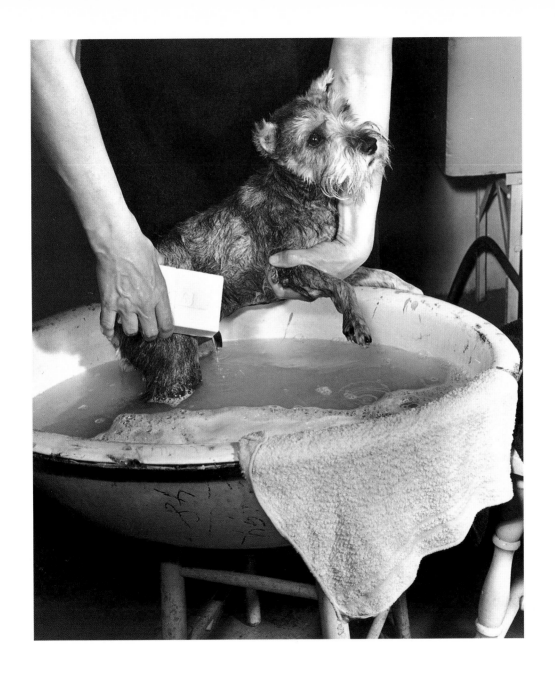

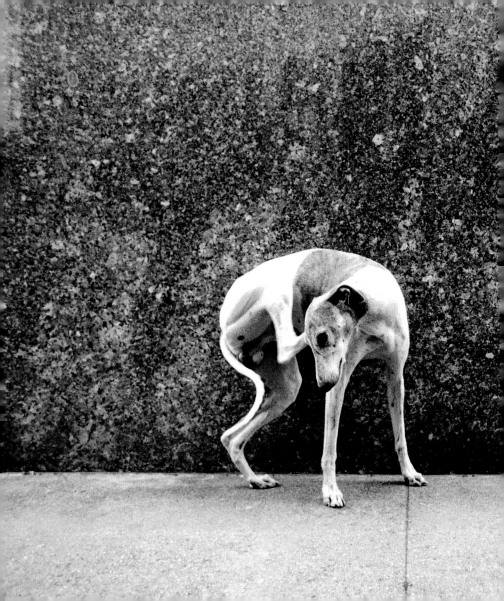

LAURA BAKER STANTON
Baroque Takes a Break
New York, 1991
"We'd been shooting for the *AKC Gazette*
and my Whippet Baroque, a very serious model,
suddenly decided it was time for a break.
I was so exasperated I took the picture
anyway. People have told me he's got a
criminal mind. For a while he lived in Dallas,
where he wound up racing a police car.
They said they were going thirty-five,
and he was going faster."

LISETTE MODEL
Harborside, New York
c. 1945

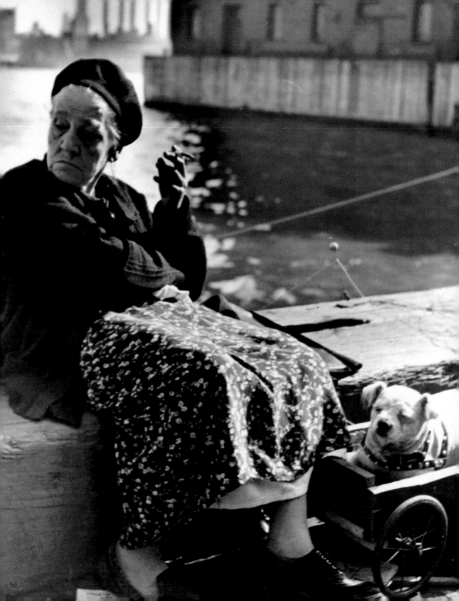

PHOTOGRAPHER UNKNOWN
Richard Tauber and Dachshunds
New York, October 23, 1931
His Dachshunds in his arms, renowned German
tenor Richard Tauber arrives aboard the
ocean liner *Bremen* for his American debut.

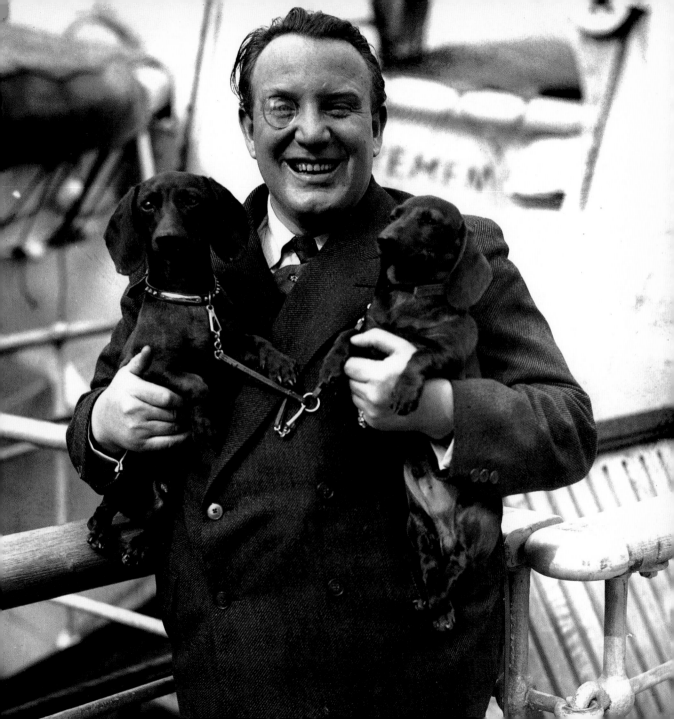

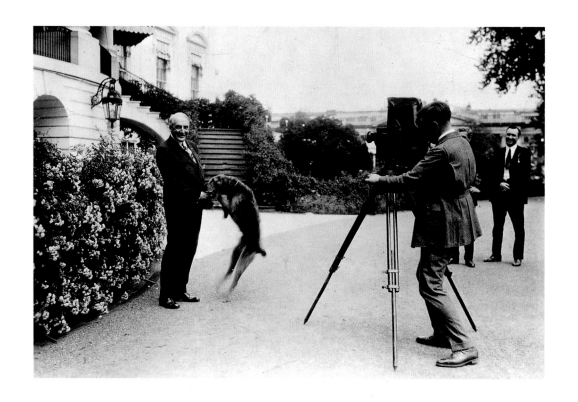

PHOTOGRAPHER UNKNOWN
President Harding and his Dog
Washington, D.C., 1922
The loyal pair photographed in the White House garden.

Opposite:
PHOTOGRAPHER UNKNOWN
Winston Churchill
February 23, 1950
The statesman and his Bulldog in an election-day portrait.

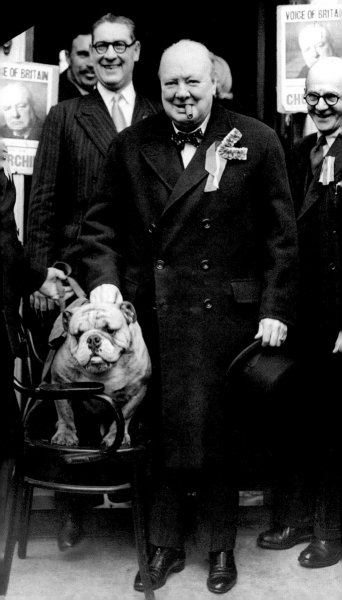

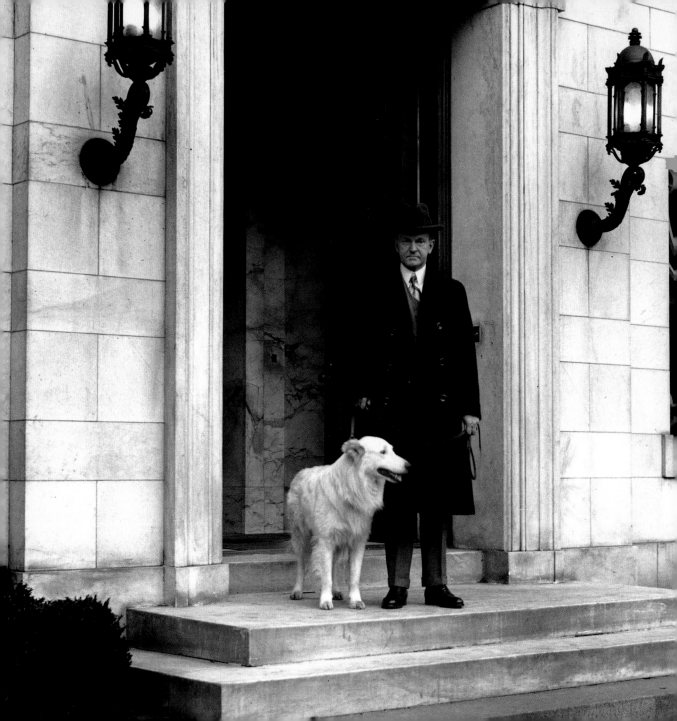

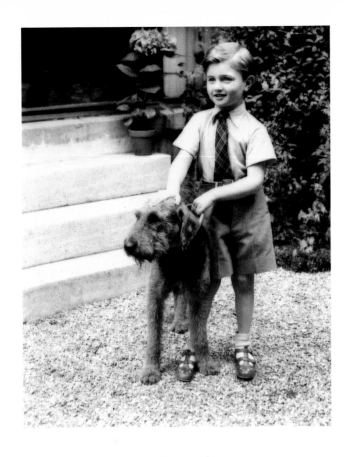

Opposite:
PHOTOGRAPHER UNKNOWN
Calvin Coolidge and His Collie at the Temporary White House
Washington, D.C., March 3, 1927
While the White House roof was being repaired,
the Coolidge household—including Collies—
moved into the nearby Patterson Mansion on Dupont Circle.

JOSEF BREITENBACH
Boy with an Airedale
Paris, c. 1935

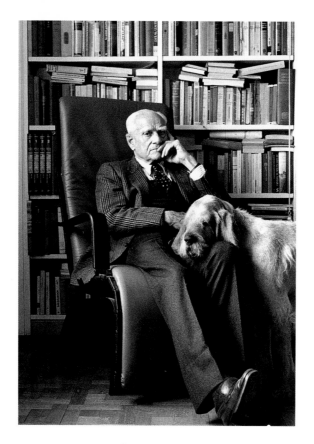

PRISCILLA RATTAZZI
Alberto Moravia and Arancio
Rome, 1988

Opposite:
CLIFF OWEN
Barbara Bush with Millie and her Pups
Washington, D.C., March 29, 1989
The former First Lady watches over new mother Millie,
an English Cocker Spaniel who'd given birth
to six puppies eleven days before.

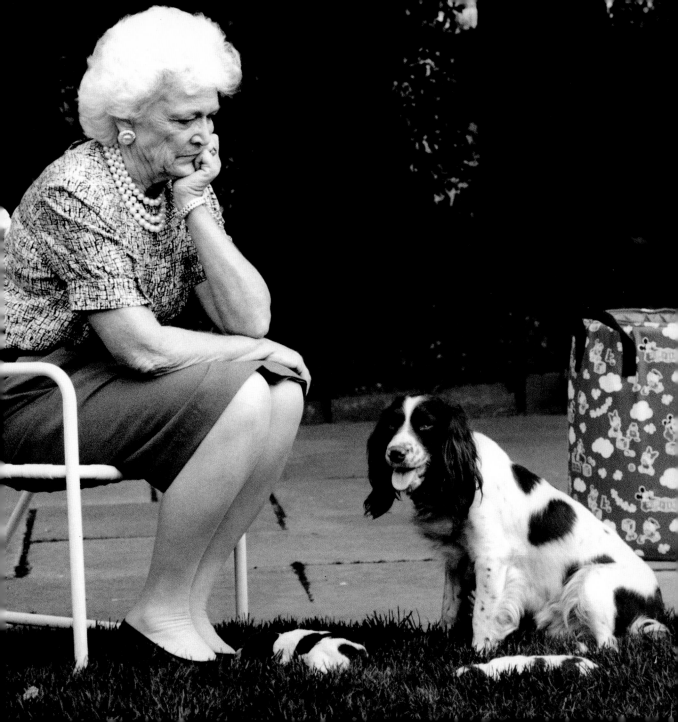

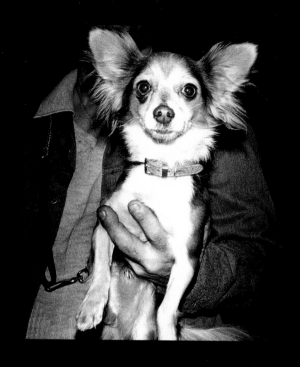

JEAN PIGOZZI
Untitled
c. 1980

Opposite:
PHOTOGRAPHER UNKNOWN
Lucky Spends Nights at Home
January 9, 1955
Alleged mafia racketeer Lucky Luciano relaxes
with his Miniature Doberman Pinscher.

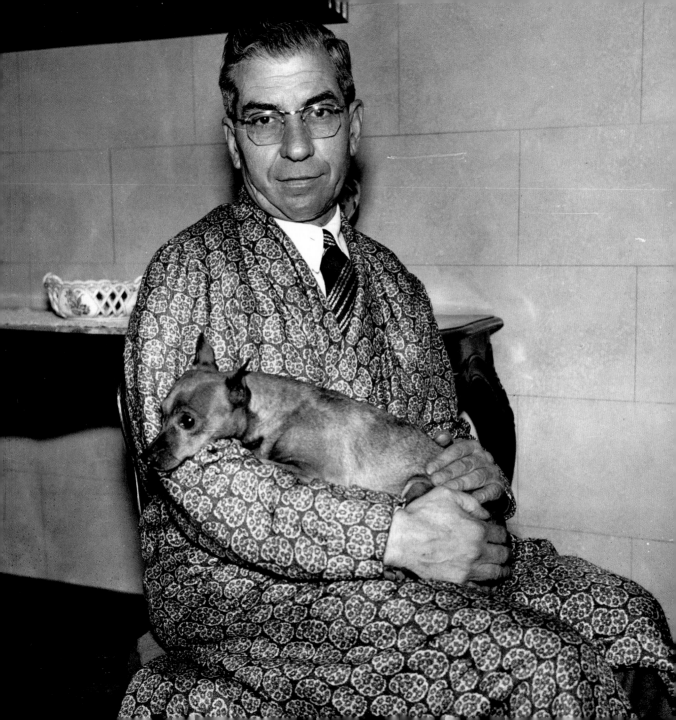

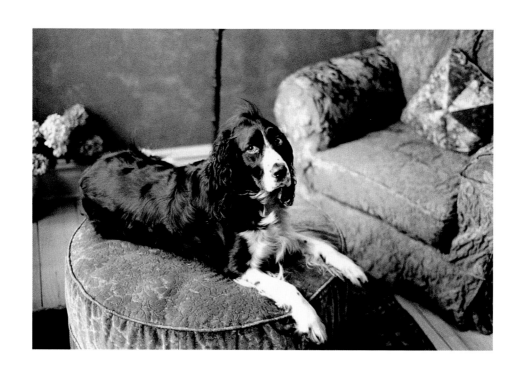

LAURA BAKER STANTON
Ralph Kletter-Renee
New York, 1993
"His hyphenated name is for his two owners,
who've been best friends for fifteen years.
He goes back and forth between their apartments."

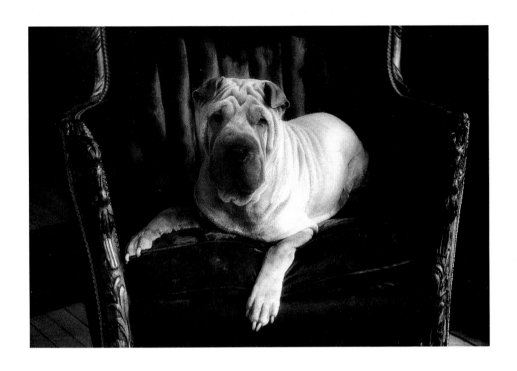

RICHARD ELKINS
Oscar
New York, 1990
"Oscar's a young Chinese Shar-Pei owned by Craig Lucas,
a playwright who was posing for me in his library.
I was really interested in that chair, which seemed perfect for an
old-fashioned portrait. And Oscar, who was running around
and being very likable, seemed like an old-fashioned dog."

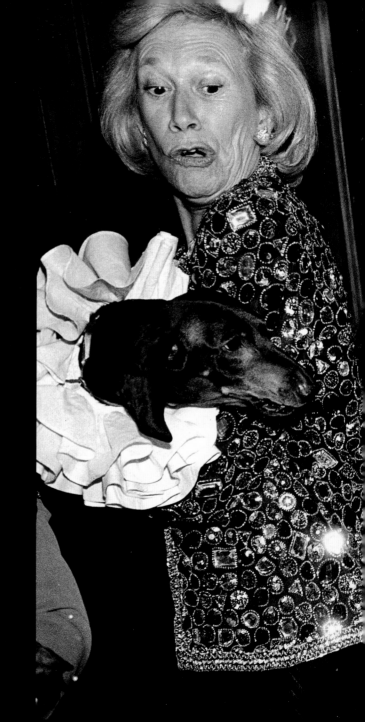

DAFYDD JONES
Archaeologist Iris Love and Philanthropist Brooke Astor
with Dachshunds at a Cocktail Party
New York, 1990

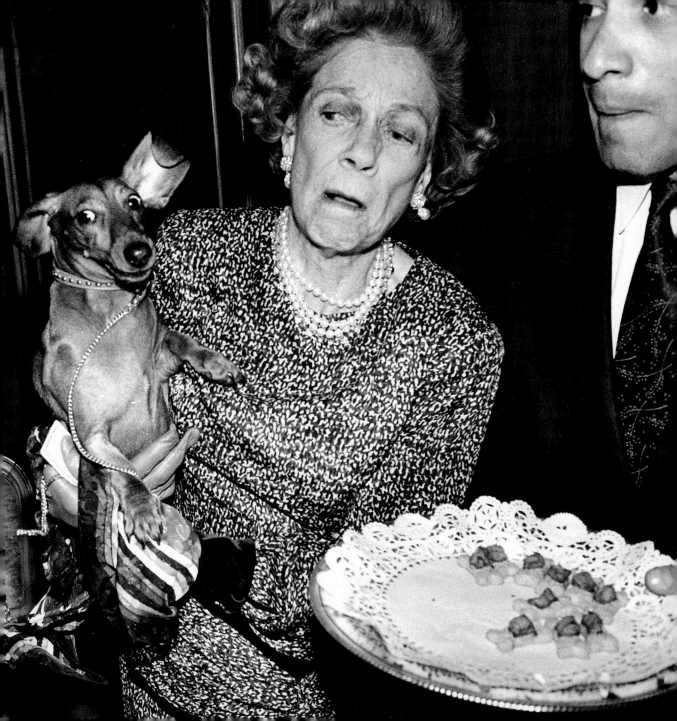

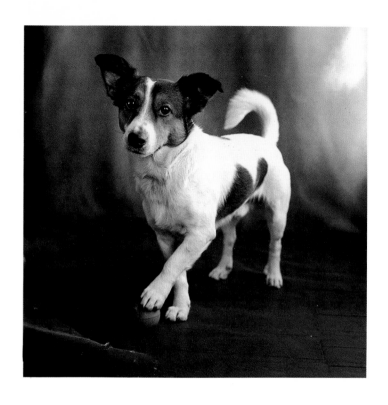

ALEN MACWEENEY
Bachelor
New York, 1993
Co-owner Hazel Hammond says: "Alen and I were in Ireland
on holiday and two bachelor brothers named Picket gave us a puppy.
We were either going to name him after their last name or their profession—
Irish bachelors are a race unto themselves. A vet tending cattle alongside the
road scribbled out a medical authorization so we could bring Bachelor back.
Now he's a great dog, fierce and brilliant. His biggest problem
is that he wants to know everything that's going on."

CREDITS

DESIGN: J. C. SUARÈS
PICTURE EDITOR: PETER C. JONES
TEXT EDITOR & CAPTIONS: JANE R. MARTIN
ASSISTANT PICTURE EDITOR: LISA MacDONALD

SOURCES